Museum, Inc.

MUSEUM
DIRECTORS
MUST WASH
HANDS

©2005 Filip Noterdaeme

Museum, Inc.:
Inside the Global Art World

Paul Werner

PRICKLY PARADIGM PRESS
CHICAGO

Prickly Paradigm Press, LLC
5629 South University Avenue
Chicago, Il 60637

www.prickly-paradigm.com

ISBN: 0-9761475-1-3
LCCN: 2005908631

Printed in the United States of America on acid-free
paper.

For Lizzie, of course.

Flaubert wanted to write a novel
About nothing. It was to have no subject
And be sustained upon style alone [...]

 He never wrote that novel
And neither did he write that other one
That would have been called La Spirale,
Wherein the hero's fortunes were to rise
In dreams, while his waking life disintegrated.

—Howard Nemerov

Actually, I kinda liked Tom Krens.

Krens, should this book wash up on future shores, was Director of the Guggenheim Museum throughout the 'nineties. He found a new way of thinking about museums without thinking about art, but he thought about museums so thoughtfully that by the beginning of the twenty-first century there were Guggenheim branches all over the world (Venice, Berlin, New York, Bilbao) with unfinished or failed projects in New York, Las Vegas, Salzburg, Rio, Taiwan— or was it Guadalajara? Krens was widely hailed or hated as the "CEO of Culture, Inc.": the man who was doing for the Art World what the new monster corporations were doing to the Global Economy.

I'm glad I worked at the museum and not for the monsters. But I learned a few things about the monsters, too, because there were parallels: the Guggenheim behaved like a corporation, and corporations thought of themselves as Beacons of Humanity.

It's nothing personal. I rarely saw Krens, spoke to him only once, and he never spoke to me except near the end when someone must have told him you're supposed to make eye contact with the crew when the ship is sinking. Then again, I spent nearly nine years at the Guggenheim as a Gallery Lecturer, an independent contractor on call to talk about Contemporary Art, Chinese Art, African Art, architectural models, motorcycles, Armani clothes, Vaseline and just about anything else Krens qualified as Art. So why not play the expert on the Museum itself, and museums in general? The best expert at figuring out what the boss thinks is the one working under him, especially when the boss doesn't know what he's thinking anyhow. Like every worker I specialized in the area least discussed: the institution itself.

It was fun. I earned a little, learned a lot, and it's time to clear out the desk in my mind. And if in the end my collective employer turned into a corporate cretin—well, even the consciousness of cretins is determined by social circumstances and it is necessary to understand those circumstances in order to educate the cretin. Think of this book as a gallery lecture, moving up a gently rising ramp, haphazardly it seems, from one image to the next. Section One describes the museum system at the end of the twentieth century—the what, if you will; Section Two, the strategies used to enforce the museum's agenda—the how; Section Three describes Krens' tactics: how

these strategies were applied, and failed, and haply will fail some more, as they're shown to do in Section Four, Conclusion. Reader, see yourself moving up a huge spiral, looking down, and up, and sideways, at the same ideas from a changing perspective. Think of a giant inverted cone rising to the heavens, ideas insensibly moving from contradiction to contradiction, thesis against antithesis at a five-percent incline, rising, insensibly rising in a widening gyre...

ONE

The genius of capitalism—and vice-versa

I

If genius consists in seeing the obvious then Tom Krens had the genius to see that works of art circulate like money. If he had a flaw it was shared by most of us in the 'nineties: he didn't realize art behaves like money because money behaves like art. In either case it's not about art, or money: it's what you think about art and money and both at once combined.

Here's how it works: a museum (any museum) has accumulated a collection that it leverages the way a bank leverages capital. The museum puts its own capital ("the collection") or the capital of others ("loans") into circulation ("shows"). As the capital circulates it accumulates more capital, which in turn is put back in circulation or leveraged for more capital.

And the Guggenheim Museum had accumulated sterling capital by the time Krens came on as director. There were the blue-chip Blue Period Picassos of the Thannhauser Collection; close in value, the Kandinskys and other Modernist works acquired by Our Founder, Sol; then the Surrealist collection of his wild-eyed niece, Peggy, along with her over-sober palazzo to house them in Venice. Finally there was the New York building itself, Frank Lloyd Wright's spiral-shaped masterpiece, commonly called The Mother Ship. Wright's building aimed to inspire us all to a

better future. It was a legend, and an asset: visitors were more likely to come for the building than the show. When he first got to the Museum in 1988 Krens took the business-school, rule-book step of working outward from the institution's strengths: the brand-name architecture, the idea of real-estate as a major asset, and Wright's utopian vision. The utopian part was risky: Krens was playing Sorcerer's Apprentice with Mickey Mouse insights.

Krens had a Master's in Art History and another in Management, meaning he had a common fault of the academic half-baked: he imagined he was thinking outside the box simply because the box in which he thought was the latest in boxes. Reader: you may have noticed two paragraphs back that the "capital" involved in collecting and circulating artworks is of a different order than bonds and dollar bills. It sounds easy to substitute one for the other, and it's done all the time, until you need to cash in at the gambling table. I don't think Krens understood that.

You can tell, because his first major action was to "diversify the portfolio" by selling off some of the bluer, chipper paintings and shifting to riskier investments. In 1990 the Museum bought up a large collection of Minimalist works of the 'sixties and 'seventies. It continued to snap up speculative stuff, hot-from-the-studio artworks acquired or often donated because the very fact that they were in a museum gave them more value than they would ever gain otherwise or deserve, and hike up the artist's reputation in the bargain.

A well-balanced portfolio if you're thinking equities, not art. An aggressive strategy you'd call it if

you were an investment banker, and inappropriate if you were a tradition-bound museum trustee or director. Traditional museums (which usually look like old-style banks to begin with) are about preserving cultural capital by maintaining assets through good conservation, supporting the scholarship that maintains the value of the assets, sponsoring the shows that support the scholarship that maintains or raises the value of assets, leveraging their assets through loans and exhibitions that drive up attendance and consolidate the symbolic value of these assets and this type of asset in general to begin with, and this is the house that Morgan built, and Frick, and Rockefeller. But this wasn't the model Krens had in mind, and the more conservative among museum directors went bananas.

A bunch of them (directors, not bananas) contributed to *Whose Muse?*, a book with the subtitle *Art Museums and the Public Trust*, though it really should read: *Tom Krens: A Dagger aimed at the Fair Bosom of our Sacred Museum Racket*. The gist was that Krens was driving down the value of his portfolio through risky ventures, and that threatened to undermine "Public Trust" in museums. The press picked up and began to block out verbal gunfights in which Philippe de Montebello, tradition-bound Director of the Metropolitan Museum of Art and unofficial spokesperson for the League of Disgruntled Directors, met Krens at high noon. But as in an existentialist movie it was hard to tell the sheriff from the bad guy: both had the souls of bankers—just different kinds of bankers.

II

Eventually the sheriff confronts the bad guy. In this case there was nobody to confront because Krens could do little to undermine the Public Trust that museums weren't already doing themselves. But there was every reason for museums to be worried, because Public Trust is the main concern of the American art museum: trust in Art and trust in Capital, as if the two were indistinguishable. The role of the American art museum is to launder the money of its trustees and sponsors, not, as you may think, by turning one asset ("cocaine," for instance) into another asset (say, "Rembrandts"), but by turning artworks into objects of authority and trust—objects that mediate and are mediated by the worth of money. The American art museum turns art into buzz the way its owners turn pork bellies into pork-belly futures.

It is a vile slander spread by communist agitators that museum insiders (the trustees, the sponsors, the decision-makers) are in it for the money. Nobody's that stupid, least of all the people who gravitate to positions of authority in the museum world. Art is a lousy investment: there's no consistent or predictable demand, the value's all on paper, actual prices fluctuate wildly, and you get no interest or dividends. Plus, the cost of maintaining your assets is huge: at least gold ingots and stock certificates don't require acres of storage or proper cleaning and restoration and insurance, or commissions on sales and acquisitions, or the cost of hiking up the price of your investment by

bidding against your best buddies at auction, or any of the many ways of building your pool of potential buyers by hype and by buzz. Sure, you read about fortunes made in art, about holding companies (the Wall Street, not the Janis Joplin, kind) being set up to invest in art. Periodically you open up the paper and there's a picture of an economics professor who's just proved mathematically that art's a terrific investment, and the first thing you want to tell the professor is: "define your sample." There's something they teach in Statistics 101 called "external validity," which means before you measure beans you'd better have a definition of what a bean is. Too bad there's no consistent definition of what's art.

And sure, you can get rich off of art. You can also get rich off the horses, and the odds are better at Aqueduct, with less fixing. Read the fine print in the art-world tip-sheet and you'll notice there's no verifiable statistical basis to argue whether art goes up or down in value over time, or in spirals. There's no statistical basis because there's no valid statistics, is why. It's called internal reliability. And there's no valid statistics because art dealers, collectors and museums are the last people on earth to open up their books for the simple reason that it's not about how fast the nag's gonna run, it's about how fast they're gonna make you *think* it's gonna run: *I got the art right here, the name is Jan Vermeer....* Even Adam Smith couldn't figure how art fit into his tight little scheme: it's all exchange-value and zero use-value. Like the pants with three legs in the Orchard Street joke, art isn't something you use, it's something you buy, you sell, you buy, you sell.

All of which made art a perfect investment in the 'nineties, when art-for-profit corporations went busting out all over, buying up art and promoting shows. Sooner or later you'd find some billionaire in bed with your beloved, but that's what museums are for: they pimp for art and charge the taxpayer and make every sleaze-ball with a checkbook look like a Beacon of Hope for the Struggling Human Race. Plus, they even tell the world what's art and what's not, which is more than I'd ask of any sane person. Even in Europe, where the private and public sector are traditionally at arm's length, there are growing and persistent efforts to turn over public exhibition spaces to private enterprise, but then free-market liberals are always pissing in America's footsteps, and there's a substantial segment of the European business and government elite that gets its talking points from old copies of *Time* magazine. In any language the figures don't add up.

The illusion that art museums could be run for profit like everything else was derived from the notion museums themselves had worked so hard to foster: that art and capital were all one and circulated in the same manner. By the early years of the twenty-first century a few museums were trying to back out of their relationships with the corporate crowd as they realized the profits were all on the side of the corporation. They found themselves caught up in their own self-deception, except for Krens, who seemed to enjoy it. He who sleeps with the Devil must have a long @#$%!

III

The museum's Dance of Debt goes back to the Enlightenment of the eighteenth century or, more precisely, to the beginning of the French Revolution, when unfettered capitalism was loosed on the Old Regime and the junk-piles of art and craftsmanship collected by kings and religious orders over ten centuries were systematically stripped from palace and monastery, first in France and then wherever the armies of the Revolution (and, following that, of Napoleon's Empire) ranged and ransacked. From this mess the modern art museum emerged, tah-dah. From one side came calls to destroy the Old Playthings of Perversion: churches were torn down, monasteries closed, statues smashed. From another, artworks (especially the portable kind) meant irresistible wealth for any critic, speculator or scallywag with the kishkes to grab them. Depending on how you phrased it the ownership of a lacquered table from Versailles could make you rich or get you the guillotine as a greedy speculator, or get the guillotine for whatever was left of you after that as an Apologist for the Depraved Playthings of Tyranny and their Sniveling Lackeys. It doesn't seem to have earned anybody in the military the firing squad for looting, though, because the state was brought in early to play the role of impartial arbiter. Just as the state had a monopoly on violence in war and peace, so, too the state was given the ultimate say about art.

The trick was, *first*, to argue that the "real" value of an artwork had nothing to do with whoever

once used it for toilet paper: Art would transcend its originary mud like a lotus. The argument hinged on distancing art from its social context, Rubens from royal butt. Intellectuals of the late eighteenth century had plenty of experience wielding that argument: it's a talking point in the rise of the Modern Order, the strongest ideological link between the French *Philosophes* of the mid-eighteenth century and Young Man Marx in the mid-nineteenth. The Museum as we know it was explicitly set up to demonstrate that the "real" value of artworks transcends at once their past use-value and their exchange value. What Goethe once said about aesthetics applies as well to money: as long as you yourself set the terms of the debate you can manipulate meanings forever, which is pretty much what people who work in museums are put there to do. Hey, it's a living.

Museums in the French Revolution were among the first to show artworks by historical period, based on the tidy and self-contradictory concept that each society has its own art but the meaning of art in general belongs to none, except that in practice it belongs to those who own the museum—those who set the terms of the debate, remember? The meaning of museums is that they transcend History: the visitor is always passing through History and always already beyond it, in a tension unresolved between the linear narrative of walking *through* the galleries and the immanent meaning of the self-same saunter *as a whole*. This tension and its temptations haunted the nineteen-nineties, a time when orgasmic intellectuals and

other f*&k-you mamas stood on every street corner, rolling their eyes over the coming End of History.

Second: the founders of the New Art Order needed to persuade themselves and others that the actual value of artworks transcended filthy lucre in the here-and-now as surely as their "real" meaning had transcended their exchange- or use-value in the past. The use-value of art is that it has no use-value. It's all perfectly logical, and perfectly self-serving to the passel of thieves (military, civilian, curatorial, collectorial) who ranged over Europe and Egypt in the years following the fall of the Bastille, and who range over the wide world, still.

And (*third*): the state became the resting-place for all the unresolved contradictions of the art market, just as it was the arbiter and final resting-place of all the contradictions of modern society. The founders of the museum system knew John Locke's elucubrations about the role of government, and like a bunch of squabbling kindergartners they hid behind the skirts of State, the designated arbiter in the War of One Against All for that Priceless Sèvres Porcelain. The real purpose of collecting art was not to make you rich (fie, fie!), it was to serve the people by preserving those treasures that somehow would improve the breed, with the imputed blessing of the breed itself: the people and the state that was supposed to represent the people, which representation of course was an incontrovertible fact since the state was kind enough to protect the arts that were the glory and consolation of the self-same people who... but we seem to be going around in circles, here. When the French nation

went to war it was unclear from the accompanying rhetoric if the expected theft of foreign artworks was to be an unfortunate byproduct of war or its true purpose: France was already the legitimate embodiment of its own people in war and peace and the collecting of art, and through the magnanimous act of ripping off the art of all nations France would give said nations their legitimate place in history as surely as it gave them a legitimate place among the nations by conquering them.

Fourth, and finally: the aesthete was the person who could tell the difference in art, the one who put himself at the service of the State, or Beauty, or the People, or anything but his own greed. As the sociologist Pierre Bourdieu suggested, in the Modern Era the symbolic value of art begins to look like the upside-down image of its actual use-value—he calls this an "interest in disinterestedness." The curator, the connoisseur, the aesthete, all end up sounding like Proust's Swann, a brilliant, sensitive man who doesn't have a clue why he's drawn to the flowers between Odette's breasts.

This fourth point is the kicker, the moment when the entity that invented the museum and its ideology reinstalls itself as the true arbiter of museums, throws down the pretense of deferring to the state, and assumes the controls it had temporarily ceded. By the nineteen-nineties that circle seemed to close in on itself as the art world elite faced its own golem with the certainty of destroying it. This was when the concept spread widely (with the help of various tax-exempt institutions) that the state was super-

fluous and free-range capital could and would run itself, by itself, forever world without end, Ah, Money. In most European countries the value of museum artworks was still backed and validated by the full faith and credit of the state because the state still took itself seriously as an arbiter of class conflict, but in America and in other countries (Japan, for instance), there was little doubt that the interests of art in general coincided with the interests of the people since those same interests happened to be those of a ruling elite. As James N. Wood, Director of the Art Institute of Chicago put it, "the authority of the American art museum is derived ultimately from our Constitution, which assured the climate in which private individuals could create museums for the public good." Mighty white of them, eh?

IV

Translation: the American art museum shores up its authority by, while, and in order to demonstrate that the values of free enterprise are coterminous with the values of art. And of course those values are coterminous, aren't they? Altruism, Egalitarianism, the Mind over Materialism, right, Boss? The fact that a former museum trustee is busy loosening laws against looting in Iraq; that another has been caught with smuggled antiquities in her home; that the Caravaggio on loan from a potential donor contains troubling passages that raise questions about its imputed caravaggioicity and questions, therefore, about the benefit to museum and donor alike of the absence of an honest, open discussion of such passages; the fact that scholarship is routinely used to validate and promote works of art that happen to belong to a founder, sponsor or trustee of the museum that happens to promote the scholarship to begin with; or that temporary exhibitions are means to hype the authenticity and value of the sponsor's holdings—well, let's not worry our pretty little heads about that. As Montebello put it, "It is the judicious exercise of the museum's authority that makes possible that state of pure reverie that an unencumbered aesthetic experience can inspire." By the same logic the absence of a "state of pure reverie" interferes with the "judicious exercise of authority"—but we'll get to that. The challenge for the museum director is to build up his institution as the stage upon which Egoism,

Autocracy and Material Desires reappear as their own opposites and complementaries.

It's hard to tell if museum directors believe this crap or if like the old Roman entrail-readers they giggle whenever they meet. The party line is that the daily bread of free enterprise (speculation, manipulation, the creation of reputations and the twisting of perception) has nothing to do with the champagne of art. The legal principle behind every museum in America is that the trustees could, if they wanted to, sell off the Seurats and head for Bermuda; the moral principle is that they don't. So the moral authority of the museum (or "Public Trust") derives from the appearance of a happily resolved conflict where in fact there may be no conflict at all between self-interest and the interests of art.

Think of it. If one-tenth of the Picassos in the world came on the market in one day the market would collapse. If ninety-nine percent of the Rembrandts in the world were kept off the market (and they are) then the demand for the one percent left would be tremendous—and it is. Unlike beans and peanuts and pork bellies, though, the demand for Rembrandts is fostered by the same people who keep the stuff off the market to begin with: first you hike up the price of a Raphael, then you turn around and donate the same Raphael back to the museum for a huge write-off. Through a museum trustees and sponsors can at once protect their assets, jack up the value by holding the museum's assets off the market, further hype the value of their own holdings by promoting tax-free the museum's holdings, and earn brownie

points ("symbolic capital") for proclaiming from the rooftops that their assets are Above Mere Financial Worth. In this narrative social class (as defined by the ownership of a Raphael, for instance) does not after all derive from the fact you've got the money to buy the Raphael to begin with. Now—reread the above paragraph and substitute "motorcycle" for "Picasso," "Raphael" and "Rembrandt." Doesn't exactly make sense, does it? And now you see why Krens was a threat—not to the museum as such, but to beliefs that wealthy museum insiders were barely capable of articulating for themselves.

There's a lovely term in economics, "externalities," meaning anything economics is either not designed to cover, or designed not to cover. Museums are instruments of the second activity, tools for the encryption of one value (cash) as another (symbolic capital). That second value is preserved by the judicious, expert and continuing redefinition of value; which is to say that in the museum the value of artworks is to the value of money what the value of money is to whatever else money is supposed to represent: a highly tenuous relationship, unendingly open to manipulation. And this manipulation, this movement back and forth between symbolic capital and capital *tout court*, is the endless occupation of the museum. The museum director's job is to represent the interests of the trustees and sponsors by redefining the imputed interests of the public, and to maintain a focus on the idealized value of the collection and away from its other, more mundane values. When someone says a work of art is priceless they mean it, not in the

sense that is has no value but that its value is not immediately apprehensible except dialectically, which puts it beyond the ideological competency of most art historians, and of most American economists as well, come to think of it. The system of valuation and exchange involved in a work of art (or any item of cultural production) hinges on simultaneously denying the liquidity of the object, inventing a new, other, exclusionary explanation for its existence and, finally, revaluing the object in terms of other criteria, unfathomable to anyone but yourself and a few trusted accomplices. It's a system so much more complex than anything an economist could dream up that you have to forgive the Montebellos of this world for falling back on smug prattle. The beauty of capitalism is that it has such a limited range of explanations for what goes on during a financial transaction. The beauty of art lies in the unending depth and range of interpretations thrown up whenever a work of art passes before your eyes or mine. Well, mine, anyhow.

V

Economics is all in the eye of the beholder. And as surely as laissez-faire economics dreams up goods moving unfettered through a system, so, too, the laissez-faire museum imagines artworks spontaneously moving through the perceptual equipment of the public. Glenn Lowry, Director of the Museum of Modern Art, describes museums as "part of a matrix of institutions in what the German philosopher Jürgen Habermas calls the 'public sphere' within which ideas and images, instruction and pleasure are transmitted to the public." Oh, really? What Habermas wrote was that the "public" had developed in the eighteenth century from a passive witness of royal pleasure to an active participant, not only in gossip, parades or gallery-going but in the political enterprise as well.

Whether the public ever turned into the force Habermas fantasized or not, the museum today still can't get around the old aristocratic notion that the visitor is not an active participant but a passive vessel, one to whom "instruction and pleasure are transmitted." Lowry had the wrong German, he wasn't paraphrasing Habermas but Friedrich Schiller, the Wunderkind who described cultural institutions as "the communal channel through which the glow of wisdom flows from the intelligent, superior part of society and spreads itself in gentle streams through the whole state." Not so intelligent, actually, and certainly not so gentle: from museum workers knowledge rarely flows at all, it's dangled above the reach of the public

like a carrot in front of a donkey. The good museum workers try to empower their audience; the others are more interested, consciously or not, in underlining the existence of two kinds of people, the Ins and the Outs, those with authority to define the works and those without, the bastards and the dreamers.

Because, just as it's good banking policy to uphold the meaning of money (especially among those who don't have any), so, too, the museum's policy is to uphold the meaning of art by reinforcing in its audience those values that make the work of art desirable to begin with, and first among these values is being an audience. Karl Marx was speaking of art when he wrote of providing "a subject for the object, and an object for the subject," before he turned his attention to money. In this instance the major difference between art and money is the size and the type of the advertising campaign: it takes a hell of a lot more effort to persuade you that Rembrandts are good for you than it takes to tell you how much you love money, and you should get some soon. Art is the original commodity in Marx's scale of things because, like money, it has no apparent use-value in the Western capitalist system. Art stands at the apex of all that is unexplained, until being unexplainable becomes its own use-value. And because it has no assigned meaning the very act of admiring art becomes an adherence to a free-market ideology, consumption for consumption's own sake, unencumbered by reason: "It is the judicious exercise of the museum's authority that makes possible that state of pure reverie that an unencumbered aesthetic experience can inspire." Whether

Philippe de Montebello is a Marxist, I don't know. Ask him yourself.

There is an eerie disconnect between the reality of artworks and the "reverie," the "consolation" promised and enforced by the art museum. Museum directors are the fox and the chicken coop at once, defining the values and then distancing themselves from those same values out of professional integrity. And, as on Wall Street, the less the little man knows about it the better. Time and again, in Europe, America or Asia, the art museum directs your visit in a relationship to the artworks that does not so much summarize the hard, thoughtful work of the art historian, critic or curator as it hides it. Research, conservation, restoration, provenance, technique, costs, context are not things you'd like to know, they're things you need only know exist. The cliché that museums are not "about having fun" hides another meaning: that your visit will not be structured to help you enjoy better what you already know, or to know better what you already enjoy; or to tell you what you don't know. In the final instance it will be about being told that there are things you don't know and that are knowable, only not to you. You doubt me? Rent one of those audio-guides that have no solid information whatsoever except to go back and forth about the Hand of the Master on his Quivering Piece. Or read any number of art critics who have mastered the art of saying nothing while conveying an unbreachable sense of authority. Listen to a docent waving her hands while you regress to the state of a ten-year-old, wondering as you did back then if the purpose of

education is to answer your questions or to make sure you never ask again. Then pick up the catalog for any number of shows or go talk to most any museum professional: you'll think you're in a different world, not because the information is any different—it's the same objects, after all—but because the relationship with artworks is so radically different.

In most countries of the world you'll walk into a store and find a knowledgeable, courteous person behind the counter. You'll end up thinking, well, whatever it is I need I can find elsewhere, but here's someone who wants my business, who's respectful and pleasant and has trustworthy advice. In most countries except America, the Living Museum of Wild Capitalism. Except in museums and cultural institutions everywhere, where you're treated like a dangerous interloper and you begin to think, "These people don't need, or want, my business, they want me to think I need theirs." See? You learn all kinds of things at the museum.

TWO

The rituals of authority

I

By the end of the twentieth century the rituals of authority at the traditional art museum were going widdershins against its stated mission. Krens claimed a new approach: he would sweep away the barriers between what the museum was and what it claimed to be, between the charade of democracy and the reality of authority, between the fantasy that the museum stood above the free market and the reality that it was an integral part of it, between disinterested interest and interested interest. While the League of Disgruntled Directors was busy castigating the hookers for its own repressed desires, Krens was standing on the corner in rouge and butt rider. Michael Kimmelman, senior art critic for *The New York Times*, spoke for the League when he demanded "less equivocation, less democracy, less blurring of the line between commerce and content, and a reassertion of authority on the part of museums," as if democracy alone were about commerce, not simply about a different type of merchandise; as if the decision to push motorcycles instead of *Matisse* was any less of a continual quest for authority.

As Krens saw it there was no disinterestedness on either side. There is a sentimental academic painting of the nineteenth century, the *Venus* of Cabanel.

It's an expensive piece of soft porn, middle-class hootchie-kootchie. Or it's an exaltation of the Eternal Feminine, deep and idealizing. Or more likely it's one hiding inside the other, a means to hide from the male viewer the meaning of his own viewing. Manet's *Olympia* is often seen as a send-up of Cabanel's *Venus*, a painting of a shameless whore confronting the viewer—"she waitin' on a customer," to quote a too-young friend of mine. Well, Krens did for Montebello what *Olympia* did for *Venus*: he revealed disinterested-ness as a sham.

By the 'nineties it was open museum warfare between the partisans of "Greed is Good" and "Greed, it's Not." The American Museum Establishment had been establishmented to repress the painful awareness that museums, like other parts of the system, serve the selfish interests of a narrow segment of the popula-tion. Kimmelman and kin thought this was all under threat from Krens, but the Guggenheim followed the same operating principles they did: authority to define what was to be consumed or circulated; encourage-ment of consumption for consumption's sake; and a deep, abiding interest in dissimulating class distinc-tions behind a system of consumption. Montebello, Krens and Kimmelman serviced the same john, it's just that Krens wasn't as much of a hypocrite.

II

If Krens had met half of Kimmelman's execrations that would have been something to cheer about. But the fact that most museum directors lived in Old Regime France didn't mean Krens lived in the twenty-first century.

Krens had a brain like tofu: it absorbed the taste of others without having any taste of its own. To the stodgy conservatives of art the Guggenheim was the equivalent of Clintonian Neo-Liberalism and Krens its Bubba. Krens had borrowed Clinton's rosy-cheeked trappings all right: the utopianism, the surface populism, and most of all the innocent faith that all of the barriers of class had come down like so many Berlin Walls of Culture, that an Invisible Hand had erased all distinctions in the art world as it erased them in all realms, everywhere.

Invisible Hand, my foot. By the mid-'nineties museum directors had figured out along with the rest of us that the worldwide system of production had radically changed with the advent of the PC, then the Internet, but no one had begun to figure out how relations of production were changing. It wasn't that more information was available (which everybody knew) but that people would now process information in new ways which in turn would modify their needs and how they met them. Our relationship to that information (be it stock market quotes, the value of a Mickey Mouse watch or the mysteries of art) was changing, and with it our relationship to culture, the boss, the

culture of being bossed and the bossism of culture. The League of Disgruntled Directors knew there were distinctions to enforce and they believed their job was to enforce them. It had begun to dawn on them that new methods of enforcement were called for and they were trying to figure out them out. Looking around, they saw that Krens had broken ranks—the Class Traitor of Culture.

For his part Krens seemed to think he'd overcome these problems—but he hadn't. The Kimmelmen saw class distinctions collapsing; Krens didn't see the distinctions in front of his nose. One of the most charming aspects of his personality was a curious combination of total indifference to us foot soldiers and total trust—as if we had no choice but to do what was expected of us; as if authority was a natural process. A friend of mine, an artist, once spent a full hour with Krens, trying to persuade him to back a project. Krens listened in silence, staring into space, except his feet were on the desk and in my friend's face. Like Clinton he'd bought into some vague utopian notion that we're all in it together, struggling to the stars. All he had to do was apply the principles of free-market capitalism to the museum as a whole and the pesky little details would take care of themselves.

For a while everything worked, and the Mother Ship sailed forth on golden waters, unaware it was floating on pee. If you liked art (which I do), and you were self-motivated (which I am), and you didn't give a hoot about class distinctions (on which I'll pass), then working at the Guggenheim was like walking

down the street with the key to Paradise on your pinkie. Perhaps the Guggenheim, like any other successful organization in the 'nineties, was brimming with yuppies on a cocaine high, but I wouldn't know, that's not my crowd. Of course many among us were high on power and money, but that's not my crowd, either: I'm an art-lover, not a fighter. All I knew was artists and art historians like myself, downtown types in an uptown world, giddy on art and experience. One day my dispatcher Nicole asked me to give a lecture on the history of Chinese Art at some small college: we had a big exhibition coming up and since I'd just pulled a PhD I could pass for a scholar, and therefore a scholar of Chinese Art. I had six weeks to do that, and I read like an *ashura*, and that was when I gave up being an art historian and became a critic, someone with the courage to turn aside from the vast store-house of his knowledge in favor of that freshness and spontaneity that arise out of first impressions—with good reason.

All of us, including Krens, had the same blind faith in the Internet. In January 2001 Krens was invited to address the Walhall' of Neo-Liberalism, the last meeting of the World Economic Forum before the Götterdammerung of 9/11. There he envisioned the "museum of the future" as:

> a large triangle with the exhibits at the top. Below it is the catalogue, 10 times larger, containing additional information that cannot be shown. The block below that, 10 times as large again, will contain the instruments and the technology that

allow users to access all the information relating to the exhibit. Below this block is the Internet, 10 times larger once more, with a limitless potential to stream videos, text, photographs and archival information.

In retrospect, Krens' naïve spatial view of "the Internet" is less disturbing than his naïve Euclidian view of the museum. Krens could only visualize cyberspace as a container for art; he had the same conception of the real space of the Guggenheim Museum. In his view Wright's architecture didn't even do for art what the skin does for the body, it was more like the cheap plastic jewel case for a CD: no dynamic interaction between container and content, no chance that each would change the other, no awareness of inevitable tensions between information and conveying information. To Krens the Guggenheim building was like a box of corn-flakes: container, plus decoration.

Like many artists of his time Frank Lloyd Wright had followed the utopian argument that all art aimed for "its original and its ultimate end: architecture." Wright designed the original Guggenheim building not only to *house* art, but to sum up the visitor's experience: your progression from one artwork to another, up the winding spiral of the Great Rotunda, was a march to the stars. The meaning of your visit was the physical experience of the building itself, and that ingrown tension between the architecture and the art, between Wright's overall vision and the details of each work, had conscious utopian thrust. In a number of showy spectacles at the Guggenheim New

York, Krens took up Frank Lloyd Wright's ideas about the functional integration of architecture and art, and trashed them.

Wright's original building had been considered overly manipulative from the day it opened: visitors were led, almost unawares, along a slowly rising ramp from one painting to the other in an apparently linear fashion. This straightforward progression was an easy target for proponents of heteroglossia, meaning those who felt it was their right as Americans to look at motorcycles in any sequence they goddam wanted. "The function of a museum is to create a situation in which viewers do not feel they are tyrannized," Krens explained to his Naphta-kissing pals up on the Magic Mountain, with a telling turn to the double negative.

By the early 'nineties the idea of a linear progression from one artwork to another had become abhorrent, first in academic, then in curatorial circles, and the Name of the Beast was Metanarrative. The Museum of Modern Art had long stood in the vanguard of noodnicks for its display policies: years before PowerPoint its permanent collection was laid out in a sequence as rigorous and predictable and dull as anything PowerPoint would eventually provide. But in the 'nineties MoMA switched to a hodge-podge of thematic arrangements, so you'd pass from a room devoted to naked people into another of paintings with a lot of blue. What they planned to do about paintings with a lot of naked blue people in them, I don't know. In theory this represented a radical break with the bourgeois past. In practice there was nothing to replace it except a bourgeois present.

This attack on metanarrative was overblown, borne of a narcissistic sense of curatorial omnipotence. Academics of the 'nineties were like Spiderman, moral teenagers whipping themselves for their secret, irresistible, fascist powers of oppression in order to avoid noticing they had no power to begin with. Nor was the museum visitor as powerless as all that: visitors usually bring their desires and agendas to the museum, and when it comes to writing their own script they can play Walter Mitty with the best of them, damn the curator full speed ahead. I never metanarrative I didn't like.

Besides, the system for displaying artworks was never that linear to begin with, and Wright's spiral even less so. Sure, your walk along the ramp at the Guggenheim gave a single succession of artworks on your right hand, but the twelve concrete pillars rising along the walls allowed for thematic sections while your left flank was open to complementary views of other artworks on all sides and levels of the Rotunda. Wright had effectively solved the problem of a museum in which you simultaneously saw the sum of all art while examining each work in succession. The common complaint since the building opened in 1959 was that Wright's design made the artists look bad; it only made the bad artists look as bad as they'd been to begin with, if by bad artists you mean those who were incapable of engaging with their environment. Other artists found their work improved, because the work itself was able to expand its scope and move outward, for instance the minimalist Ellsworth Kelly who had some say in his own retrospective and placed his broad, basic canvases so that they made sense in a

vertical line up the sides of the rotunda and along the horizontal line up the ramp, as well. "Form is the ultimate gift that love can offer—the vital union of necessity / With all that we desire." Says Adrienne Rich.

The Guggenheim tried to suppress metanarrative; it was like nailing Vaseline to the wall. Exhibitions were planned to smother the linear sequence of artworks under a decorative "design" the way new-rich people hire an interior decorator to hide their own lack of taste. The Rotunda was now clouded in "atmosphere" and the atmosphere got more cloying with every show, from *The Art of the Motorcycle* in which the spiral ramp was coated in claustrophobic chrome to the *Armani* show in which the gallery space was closed off from the central shaft by white gauze. Wright's organic integration of architectural function with symbolic intent was displaced by pure, passive symbolism: hard-edged, post-modernist Terminator *Schlag*.

This was not lack of taste but lack of confidence. A few months after Davos the Guggenheim put on a show of Nam June Paik, the aging iconoclast. Paik had been known in the 'sixties for aggressive attacks on electronics and technology: re-wired TVs, stuff like that. He also liked to push pianos into the orchestra pit—not his own pianos, I recall. Now, forty years later, his art seemed more and more melancholy, not so much technology as a booby-prize for the inevitability of technology. The Guggenheim ramps were festooned with greenhouse plants while monitors in the bushes played endless loops of sentimental 'seventies variety shows. Montebello's "state of pure reverie" was displaced by a pleasant buzz, like being

inside a jukebox in Zihuatanejo. Paik's technology was sketchy and ludicrously outdated, but then he didn't really *use* technology as much as he put technology on stage, just as Krens didn't really address Wright's architecture but merely dusted it with sparkles. And the decor was as decorative as the art: the greenery and flash, the sense of "being in the right place" were the only justifications for coming. Maybe that was the point: if Paik's technology had been half as up-to-date as it claimed to be the visitors would have gotten it all online to begin with.

The most successful presentations at the Guggenheim were the ones that were at least conscious of their own nostalgic content, like the attempt to reconstitute some of the atmosphere at the Universal Exposition of 1900, or a reconstruction of the Guggenheim's original plans for gray-walled, dimly lit galleries with canned Chopin in the background. Certain post-modernist activities engaged with the past, others merely recycled it for want of anything better; and those that merely recycled what they imagined to be the real world ended up in a losing competition with that world, as in those nineteenth-century exhibitions in which a view of the Andes was framed with real live palm trees in pots, or those slick contemporary photographs the Guggenheim loves to collect.

Of all ambivalent exhibitions the most ambivalent—and most successful for it—was Matthew Barney's *Cremaster Cycle*, because it brazenly engaged with the inescapable architectural theme that was the museum itself. *Cremaster-the-Show* was either the

complement or summation of *Cremaster-the-Dreary-Set-of-Sophomoric-and-Poorly-Directed-Movies* whose narrative in part was the Hero/Artist/Director's ascension to the heights of the art world, starring the Wright building itself. *Cremaster-the-Show* was of all T. Krens productions the one that degenerated most obviously into self-parody, and that wasn't bad: it was a grotesque and graceful pratfall between the chairs of metanarrative and ornamentation. The best part was the irreplaceable: sculptures and props made out of unusual materials like beeswax, some oddly sensual form of plastic, and the long flow of Vaseline that spread down through and over the sides of the Guggenheim ramp. At last here was a democratic show, and a show that had to be experienced in person: artworks you could slip on, or put your hand through. Within days of the opening, though, word came from On High that Matthew Barney's sculptures now belonged to private collectors and were not to be touched. Besides, the rabble had been dipping their hands in the Vaseline and smearing it on the walls. Touching and feeling and the sensuality of raw perception were banned, and the show veered overnight from eroticism to pornography. Art was something you learned about after all, not something you experienced directly; like sex, it was something you watched in the dark. It was, to use Paolo Freire's term, bankable.

Shows at the Guggenheim were supposed to be fun, not because they were infantile but because they didn't try to console you for not owning stuff, they didn't make you feel like an interloper at the table of the Good, the Beautiful and True. But in the end they

all edged towards information about something you would never experience directly, and they did so more insistently on the whole than a traditional art museum. After two hours of senseless mano-a-mano with Barney's esoteric obscurantism you were still left wondering if you wouldn't have been better off at home with Google Five-Fingers.

The catalog was the second level in the Great Pyramid of Krens; it was just another joker in his house of cards. Catalogs are what shrinks might call a transitional snobject: they're tokens, a paper T-shirt, a rich man's Been There, Done That; casual visitors get them as souvenirs; they're given out for buying a museum membership. They're objects of bright pride, or rather, pride in being bright, and they guaranteed an income as surely as a Wright or Gehry building guaranteed a "gate," a minimum cash flow no matter what was showing. And because catalogs sold regardless of content there was little interest in catalog content.

In his Davos speech Krens spelled out the traditional vision of the catalog as empirical data plus pictures. Actually this was a narrowing of the traditional role of the museum catalog, which manages simultaneously to reinforce legitimacy through content and snob appeal through form. But the narrowing was unintentional: at the Guggenheim information passed through the catalog like beer through a teenager.

The Guggenheim's catalogs were more likely to contain criticism and essays than empirical data. A good number were written in Kraussian, a language

related to Fustian that developed in the late 'sixties among followers of an obscure academic critic, and whose main purpose is not to provide information or foster debate but to protect the speaker from accountability, which is why you still hear it spoken among desperate gallery owners and junior faculty hustling for tenure. Accountability and trust were supposed to be the common coin, the glue that held the museum together, but there was too much variety in tone from catalog to catalog, too much of a buzz-tone from far off in space to give a cogent image of the Guggenheim to the outside world. For those of us on staff the catalog sent no message whatsoever: you could hardly expect us to read off the same page when the page was gobbledygook. At least the catalogs freed us from the tyranny of being on message, especially those among us who did our own research and had our own opinions. Plus, you could trade in your own, overpriced copy at a bookstore without a twinge of guilt: you weren't going to need it.

Besides, there was virtually no in-house scholarship at the Guggenheim, and never had been: no research library, no regularly funded research programs. The majority of curators were strictly ad-hoc: they didn't nurture the collection, they organized shows. The Guggenheim was halfway to a Kunsthalle, a not-for-profit institution that has no collection but acts instead as a glorified gallery. It was a popular choice in the 'nineties because Kunsthalles could slip unseen into tax-exempt fronts for real-estate speculation. Many were holding companies with a not-for-profit charter; some didn't even hold shows. Others

had solved the problem by specializing in "process" or "performance" or "conceptual" art. You tossed a plane ticket at an artist to come act out or strew garbage around, and that was that: no money down for guards, or framing, or transportation, or insurance, and more often than not the actual building was funded by the local Arts Council, subsidizing speculation in local real-estate under the guise of culture. The Guggenheim had a lot more in the bank, but even so, dark rumors circulated that the collateral—I mean the permanent collection—was not what it was cracked up to be; that many of the works were never shown because so many were in poor condition or were simply scraps of paper. Krens seemed to be gambling on a collateral he blew out of his ears like a junk-bond gambler, but the return on his investment—the justification for the gamble—was made out to be the spontaneous appearance of hordes of visitors through the galleries. This was the naïve economic thinking of the hotshot 'nineties, and if you believe in it I've got a New York landmark building to sell you.

III

And attendance soared, especially for shows like *The Art of the Motorcycle*. Krens himself curated, and it was huge, starting with the earliest model (a wood-wheeled clunker that sent clouds of hot steam up the driver's derriere) and on up the ramp through the Harleys and the Indians and the crotch-rockets. Outside on Fifth Avenue, the hogs covered the sidewalk.

And it wasn't just the number of visitors but the variety, from Dykes on Bikes to yuppies and back. It was great to work that show because you weren't lecturing at visitors, you were talking to them. It's a humbling experience to explain v-twin cylinders to a couple thousand pounds of studs and leather and body hair that happens to know more about the topic and in different ways than you could ever dream of, and isn't exactly afraid to say so. In other terms (those of Paolo Freire again) our interaction was *dialogical*: cooperative, born of a mutual exchange, reaching the participants where they lived and thought.

The *Motorcycle* show encouraged various narratives, and that helped because narratives work best when they're at cross purposes, exposing the contradictions in the work and in our own interpretations of the work. As Walter Benjamin put it, the work of art can never be confusing enough, and you don't start with that confusion, you steer by it. One day I was asked to give a private tour to a VIP, the wife of a wealthy patron and a beautiful soul. As we approached the top of the ramp she quietly remarked,

"the testosterone level's a bit high, don't you think?" This once; the Guggenheim empowered a few among its visitors to question themselves, to question the show's own sulphurous reek of machismo as one of a number of plausible, accessible plots. I never learned to like motorcycles, but as museum-going this one broke my heart.

Financially a great success, and a great failure in the long run. It was Benjamin again, in one of the most thoroughly misunderstood essays of the twentieth century, who argued that the "aura," the sense of authority attached to art objects, would survive even in the Age of Mechanical Reproduction but that it would require new strategies for its enforcement or transformation, not simply new labels. Krens imagined that circulating new objects (bikes or blouses) through auratic channels (museums) would automatically confer an aura on them and authority on the museum.

It's a museum truism that special exhibitions don't build audiences. Fifty-odd years ago a Dutch museum had a huge success with a show devoted to the art of the Vatican. Visitors were overwhelmingly Catholic in a Protestant country; they were underwhelmingly interested in art, and they never came back. The more special the exhibition the less likely it is to turn visitors onto the "pure reverie" of art because the visitors are more knowledgeable in their own area than the museum. The only way to make them permanent supporters is to include them in the museum's own approach to the topics that attracted them to begin with. If the goal had been to retain visitors we, as an institution working in unison, might

have turned the *Art of the Motorcycle* into an art exhibition by demonstrating how the theories and practice of Art, Connoisseurship, Merchandising, Curating and, yes, Lecturing could clarify the object. But the Guggenheim "brand" was associated with museums and the culture of reverie, not with Harleys, and it stayed that way: no bikers ended up on the Board of Directors apart from Krens himself who had a habit of leaving his hog by the staff entrance, perhaps to console the rest of us for not owning a BMW or more likely out of his usual, sublime indifference. The value system of the trustees, the sponsors, the inner circle continued to function as it had, not so much in opposition as in apparent isolation from the values of the casual visitor. His critics were wrong to claim Krens was trying to commodify culture: he was trying to culturificate commodities, and he failed.

IV

"I am not interested in being just an elitist institution that does not speak to a broad cross-section of the population," Krens claimed. As opposed to what—an elitist institution that *does* speak to a broad cross-section? No museum was interested in being "just" an elitist institution in the 'nineties, when the argument circulated that there were no classes anymore and we were all equal under a blazing sun of gold, *nec pluribus impar*. Like every other museum the Guggenheim was simultaneously elitist and populist, it sorted out the elites from the others under the sign of apparent equality. "To each his own," to paraphrase the inscription Wright had placed at the entrance of his building. "TO EACH HIS OWN," reads the inscription at the iron gate of Buchenwald. If the distinctions really were shrinking in the 'nineties, Krens had no part in it: the system for enforcing distinctions was no different at the Guggenheim than at any other museum. To change that system you would have to approach the visitors according to their own needs, not your own. Whether that makes me a laissez-faire capitalist, I don't know. Buy me a beer and I'll tell you some day.

Krens bragged that the number of visitors had gone from 350,000 a year to 3 million between 1989 and 2001, but it wasn't clear where attendance had risen, and for what shows, and what the investment had been for each. Besides, the actual space available for exhibitions ballooned in those years, so it's possible the ratio of visitors to square footage actually shrank:

it's easy enough to get answers when you know what questions to ask; it's impossible if you can't define your goals. And since the various branches of the Guggenheim operated under widely varying conditions (real-estate hustlers donating free space in exchange for a tax break, for instance, along with the privilege of hyping their own second-rate Warhols on the Guggenheim's walls), it was impossible to determine if visitor attendance translated into hard cold cash or even covered expenses, or, most important, whether the needs of the visitors were in any ways commensurate with the services provided by the museum—you know, the free-market model.

Anyhow, the whole question was irrelevant. If the Guggenheim, or any other museum, had actually covered its expenses through admissions that would have harmed its true function: the manufacture of exclusiveness. In this the Guggenheim was no different from the Metropolitan Museum of Art, which instituted special Monday openings in 2003: for a mere $50.00 you got a special admission to whatever show was deemed to be a blockbuster just then. The Museum was opened every Monday for, oh, two hundred of the elite. Of course you could also get privileged admission for a penny every other day of the week since admissions are by voluntary contribution and shows like that are not always crowded, least of all on a Tuesday morning when the masses are at work, the massahs come out, and sheep may safely gaze. The free-market solution would have been to open the galleries an extra day—that's assuming the goal was to cover costs, not just to restrict admission

for the hell of it. The point of attendance figures is to brag about spontaneous demand for the product, not about the money raised through admissions. It's about delivering numbers, not about the numbers themselves.

Besides, if admissions actually covered expenses what would be the point of donors and trustees and sponsors? Even in the 'nineties museums, like private universities, remained dependent operations whose cash came from private and public subsidies of their ideological functions: endowments, gifts, sponsorship, government grants, and funding. As their actual involvement in economic sidelines increased museums took more and more pride in operating according to free-market principles. Like any other corporation they could pose as living proof of the success of free-market ideology while raking in the rewards under the table, not to mention payback for hawking a free-market ideology on behalf of their donors and sponsors and trustees. Personally I wish the rewards had been a little bit less tangible since the worst part of my job was those private parties in which the Guggenheim Rotunda was closed off to the mass of the low-class so the elite from the Street could engage in pure reverie, for a fee. From time to time I'd be called in to talk about the art; more often than not I'd end up stopping some screaming dead-drunk stockbroker brat from smashing up the Chagalls.

The upper echelons at Enron were avid sponsors of contemporary art: Kenneth ("Kennyboy") Lay (apprehended), Lee and Andrew Fastow (convicted; apprehended) and all the others were enthusiastically in with the cutting-edge art world, and the Gug in

particular. Fastow, the specialist in conflict of interest, was buying overpriced art for Enron while he built up his own collection of the same artists, using Enron's funds to jack up the value of his portfolio. So what, you say; he was doing exactly what every sponsor or trustee does at every museum in America. The Guggenheim itself had a thriving sub-business catering to collector's groups by encouraging the discussion and acquisition of art as a profitable investment for all involved. Nobody blinks when Jock Van Snoot manipulates his Impressionist collection, so what's the big deal if the Fastows and Lays do the same?

That's why the Fastows and the Lays do the same to begin with: it makes them look like high-class, blue-blood old-money crooks instead of the usual shirtsleeves-up-from-the-gutter type. Like their social betters and moral equals, it wasn't for the money Fastow and the others invested in art, it was for symbolic mileage. More accurately, it was for the money and symbolic mileage: manipulating the art market made them look as if the real reason they were manipulating the real market was out of high altruism. So if it wasn't exactly for the money it was for what the art said about the money. Speculating in avant-garde art is like dealing in Argentine pesos: you get a lot of excitement for very little down.

It's not the cutting-edge art but what the cutting-edge art does for you. Max Weber (the sociologist, not the artist) asked a pertinent question a century ago: how did the first European capitalists justify themselves in their own eyes? Weber's answer was that in the sixteenth century making money

became a "calling," and this in turn called for a sign that the called was in God's grace. The difference between avant-garde and old masters as investments is that anybody with money can buy old masters, but investing in cutting-edge is supposed to require some particular brilliance. Any fool knows a Raphael's worth a lot of money, but if you buy sliced cows in formaldehyde it must be because you "get it," whatever getting the entrails and tails entails. Buying avant-garde art puts you among the chosen of a particular set, for reasons only that set will ever understand. Call it Cutting-edge Cronyism.

In the deadly, mortal words of the Secretary of the Treasury, "There are winners and losers—that's the beauty of capitalism." If that's the Beauty of Capitalism then the Capitalism of Beauty is the manufacturing of the belief that there are losers and winners: those who get it, and those who don't. The pleasure of being a CEO at Enron was very much like that of being an art-world cognoscento: if the point of capitalism is that "those who know, profit," then the complementary lesson of the art world is that "those who profit, know." To push an envelope Max Weber was at pains not to open: the public presentation of art is about the manufacture of class distinctions. The trick was to preserve those distinctions while appearing to elide them: to proclaim equality of access and exclusivity of appreciation. In the Middle Ages you got to Heaven by paying for candles and masses. Same in the twentieth century, except this time around you paid to broadcast the illusion you'd be going to Heaven for your smarts and fine aesthetic sense.

Remember, dahling, it is better to *look* free-marketous than to *be* free-marketous.

THREE

If you build it they will come.
Then you can beat the crap out of them.

I

When Lenin said the capitalists would sell you the rope with which to hang them he forgot the capitalists have plenty of experience selling you the rope with which to hang yourself first. That's what museums are supposed to do, but now, in the twenty-first century, they're not doing it right. If museums—if all institutions of high culture—are huffing and puffing mightily it's not because they're so mighty, it's because they're pushing uphill and running out of steam. Just as speculation in real estate has become the last great hope of the American economy so too, speculation in architecture keeps museums going: speculation *in*, and *about* architecture. Cold cash and fuzzy theory.

It's the Curse of Wright, the utopian's illusion that architecture will save art from irrelevance. It happened a hundred years ago at the dawn of Abstraction, and it's happening again. In the nineteen-nineties museums sprouted like mushrooms all over America on the off-chance that art would turn up and the visitors would follow, subjects for the objects— if only those buildings had *looked* like mushrooms. Behind the whole process was a redemptive theory out of Friedrich Schiller. A few years into the

French Revolution a shocked Schiller argued: "It is through Beauty that we arrive at Freedom," as opposed to the less subtle procedures in vogue at that time. The theory got a thorough workout in the next two centuries. Schiller himself saw Beauty in the life and theater of Greece: Beauty, like a bank, had a Greek façade and besides, who'd ever heard of a Greek Revolution in 1795? A number of nineteenth-century socialists saw Beauty in the Idea of Revolution, a marked improvement over the sordid Reality. And the Nazis founded much of their cultural politics upon it.

Hysterical Determinism: it's the socialism of Nazi imbeciles and imbecilic socialists, and of most people in the art world as well. Right and left, art offers the Idea of Freedom and Equality without Effort or Commitment. The National Gallery in London was opened in the nineteenth century on Trafalgar Square, halfway between the slums and the mansions, to "cement the bonds of union between the richer and the poorer orders of the state," as Robert Peel put it—the same Bobby who modernized the London Police in case the museum thing didn't work out. Then in 1857 it was discovered that the smog around the National Gallery threatened the artworks as well as the poor. There was a call to move the collection to Kensington, but how then would the poor be inspired? Logic demanded the poor be resettled in Kensington where they could be close to the art, though some barfbag baron argued the long walk from the West End to Kensington would help with the old tuberculosis. That's what they call the Healing Power of Art.

Lynne Cheney, Chair of the National Endowment for the Humanities and Bride of Frankenstein, once complained that "many academics and artists now see their purpose not as revealing truth or beauty, but as achieving social and political transformation," but for Schiller and his followers the Revelation of Truth and Beauty had a political side all along: "Museums must re-assert their authority on what beauty really is, thereby reclaiming the idea of quality in art," Michael Kimmelman thundered—or at least made a crinkly sound, since that's the sound a newspaper makes. He didn't explain how museums were going to do that without getting "political." Stringing up errant museum directors by their portfolios or tossing them into a re-education camp might seem like a good idea; it might be fun, anyhow. It just wouldn't achieve anything.

Kimmelman was only the shriller Schiller. The Guggenheim, too, saw itself leading the People to Freedom through Beauty, and its knight in shining cladding was the architect Frank Gehry, not a bad choice considering precedent. Gehry was a leading exponent of post-modernism, a movement obsessed with its own failure to reconcile the practical functions of architecture with its symbolism. Gehry was a sensitive if ineffectual thinker about the social consequences of architecture. At best his buildings look like gigantic pieces of sculpture, unrelated to their own uses and needs; at worst they look like liberal guilt in armor.

The Guggenheim turned to Gehry to design their new signature house in Bilbao, Spain. Gehry had long been patronized by the liberal multimillionaire

Peter Lewis, the Chairman of the Board at the Guggenheim; eventually Gehry bagged a museum retrospective and a commission to design a massive work in New York, a Downtown Guggenheim as pure and detached as sculpture sparkling over the gray waves of the East River, only that it looked in too many ways like a repeat of his own Guggenheim building in Bilbao, and like your average sculpture it had no provisions for parking or public access. No matter; the Übermensch mantle was thrown on Gehry's hunched shoulders by the architectural critic of *The New York Times*, in a review of his solo exhibition:

> The show is a tribute to the ideal of service: to an art form, to the City and to the continuous reconstruction of a democratic way of life... [Gehry's] methods go far toward explaining why it is reasonable to regard him as an architect of democracy. Freedom and equality [...] are everywhere at play.

Got that, boy? No need to vote, and it's *such* a long wait. No need to ask for freedom or equality, contemplating the Ideal of Freedom from a safe distance is good enough for you, through the barbed wire. Rousseau's ideal of art, in which the people are the unmediated witnesses of their own identity, had been turned on its head: the People were now welcome to witness their own powerlessness—*that* was the only freedom left to them, and the only democracy. These ideas are so eerily close to those of the Nazis that charity demands we ascribe them to naive ignorance on the part of the critic, who probably picked them up

at the Century Club where Philip Johnson, Nazi sympathizer and theoretical opportunist, held court until his death, the Doctor Strangelove of Architecture. The Hitler-huggers rewrote Schiller's ideas to suggest that only those endowed have freedom; the others are allowed to watch. The camp at Buchenwald is a death camp and a re-education camp at once: it reeducates you to be dead. It's built on the spot where Goethe and Schiller dreamt, and its ground tilts down to a heartbreaking view of the German pastoral, the paradise lost to the imprisoned, or never earned: TO EACH HIS OWN.

II

The Guggenheim Bilbao opened in 1997, the visual centerpiece of a master plan for the economic redevelopment of the Basque Region. The building was a stunner, set in the saucer of an estuary at the center of town, a metal spiral twisted to remind you of a shimmering rose, or a ship still a-building, or, in a clever piece of branding, the spiral of the original Frank Lloyd Wright building back in New York.

"The function of a museum is to create a situation in which viewers do not feel they are tyrannized." Not feeling tyrannized, it turns out, was not a goal but a subject for contemplation. Inside the Guggenheim Bilbao there were always pretty things to look at: a soaring, twisted atrium with a twisting elevator shaft, walkways leading in odd directions, curious corners. But there was no particular sense of a space being used, or penetrated. There was nothing to engage: the only tyranny you were going to be freed from was the tyranny of the metanarrative. I saw the Motorcycle show in New York and in Bilbao, and it was far more interesting in New York because there at least you found yourself thinking about motorcycles by the time you got through. Gehry's Bilbao building adapted Wright's form while suppressing its functions by shifting them to the category of symbol. Form, said György Lukács, is frozen content, and he must have known, being a bit on the cold side himself.

The Guggenheim Bilbao was wildly successful—at least for the Basque Regional Government that

originally commissioned it. Then again the Basque region was in the midst of a political crisis and its government had bigger fish in mind than pulsating rhythms and passionate impastos: to replace a collapsing industrial base; to encourage tourism; to weaken cultural and economic isolationism and relieve political pressures for autonomy. The Gehry building played an ambiguous role, as art often does: it promised alignment with international culture and an escape from provincialism, or perhaps it simply threatened local culture, depending on one's point of view or immediate benefits. The Basque Government claimed to have recouped its initial investment within a year, apart from the political payoff, but the Basque Government had gone in with this double balance sheet in mind, trading off political against financial gains. The Guggenheim had no such fallback position: trading financial loss for ideological gain was simply not a part of its mission, it was actually a contradiction of its mission.

As Kimmelman kept pointing out, K. (the museum director, not the hero of a Kafka novel) was too much concerned with the bottom line. He had to be: he never had the wiggle room of a traditional museum director. There were financial gains and losses and then there were other gains, of the cultural kind, not easily banked and not easily used to offset financial losses. The Basque Government had seen to those financial losses with a generous funding package and, most important, an agreement to cover operating costs. And a darned good thing, too, because Gehry's construction, like Wright's before him, was going to need a lot of work. This is common with cutting-edge

architecture where the architect is more interested in illustrating principles than providing for a practical function. It's especially common in American architecture, which is about speculation, intellectually and financially: the developer speculates in cash flow, the architect speculates in reputation. While the price of real estate rises the building deteriorates. Meanwhile, you build, you puff, you move on, and the money goes on gurgling down the drain of maintenance. In Bilbao at least, and for the foreseeable future, the Guggenheim won't be stuck with these costs, but a thousand provincial museums have no such option. Their fate will be sealed the day the local civic center's found to shelter a decaying eyesore, a cultural Wal-Mart after the fall.

Bilbao paid for itself, but the Guggenheim's profits would have to come from elsewhere. According to the Guggenheim's Director of Communications, "We have a Guggenheim brand that has certain equities and properties." This doesn't make much sense at first reading: the museum itself might own property, and have equity in other ventures, but a brand that owns equities? That's like saying the sizzle owns the steak.

Precisely: Bilbao was supposed to demonstrate that the Guggenheim had amassed a certain experience in attracting audiences, and the Guggenheim was saying it could sell that intangible experience—*that* was its equities. The name "Guggenheim" (with attendant services and architectural ecstasies) was to be used primarily, not to attract more visitors (who couldn't care less whether that particular brand owned equities

or was broke), but to attract major patrons and financing institutions with some kind of a stake in the museum's ability to attract visitors. K. was offering his expertise, the expertise of his staff, of his pet architect, his curators and Yours, Truly, to whatever government, power group or corporation might think to benefit.

This went beyond what museums had been doing for centuries. They, too, were delivering an audience, but it was to their own sponsors and trustees, not to a third party as yet undetermined. In old-style art museums the content of the art experience and its propagandistic purposes were one: people went to the museum (or were sent to the museum) with the expectation of an experience at once commensurate with and complementary to the ideological thrust of its patrons. I was appalled one day to see a polite group of black kids in jumpers and blazers sitting on the floor of the Pierpont Morgan Library listening to a long-winded lecture about "Mister Morgan" and what a wonderful guy Mister Morgan was. The kids should have got that lesson from the objects themselves.

The Guggenheim's stated mission was no longer making art available to an audience, it was delivering "its" audience to a new sponsor. In the process the line between "equities" (meaning one's own assets) and "equity" (meaning an interest in the assets of others) was further fudged. By tailoring each Guggenheim show to each corporate patron Krens was throwing out his own best asset, the reputation for making a particular experience consistently available.

Suppose a local government, for instance, were to start pushing for a different kind of art for their own Guggenheim branch, something more reflective of the local tradition of goat-cheese sculpture? As a matter of fact such shows periodically turned up at the Guggenheim New York, minor provincial post-modernisms from Taiwan, or Rio, or Guadalajara. Most were an embarassment: very few visitors cared about goat-cheese art in New York. I doubt there were many who cared in other countries, either.

But even if the Guggenheim were to become identified with goat cheese and motorcycles and Armani clothes, it was foolish to assume that motorcy-cles and such might become identified with the Guggenheim the way New Yorkers identify the Metropolitan Opera with Opera: some people came for the architecture and hated the art; others came for the motorcycles and hated the architecture. What Kimmelman denounced as "commercialism" was so much wishful thinking, as if putting on a show of reli-gious art made you a high-paid lobbyist at the Vatican. Krens was steering the Mother Ship where no museum had ever gone before: authority regardless of content. But if the only meaning you got from your visit was the authority of free-market capitalism then you might as well go to the mall.

In World War I, I've heard, the French High Command had a brilliant plan, avidly discussed in the papers: a) attach French flag to a little wagon; b) place flag in front of German lines with a long rope leading back to French lines; c) jerk flag back when German troops rush forward, unable to resist biological urge to

capture French flag; d) capture Germans; e) win war. Gehry was the Betsy Ross of that flag and K. was its Washington. Forget that the endowment was shrinking; that some of the collection had been sold off; that the Museum was saddled with huge operating expenses, because that's not where the money was anymore. At the Davos conference the architect Rem Koolhaas fantasized that museums had become an "independent branch" of the economy, by which he meant (assuming post-modernist architects still deal in meanings) that museums no longer depended on such minor niceties as tax breaks, ideological support, or even attendance figures to function. No: museums were the engines of a new economy, and Krens, Gehry, and Koolhaas the acknowledged legislators of the world.

Krens was trying to transmute symbolic capital into financial capital and back again as if it were the easiest thing in the world to shift assets from one column to another. He got lucky in Bilbao, partly from the intelligence of his architect, partly from considerable support, and in no small part because like the World Bank he was privileged to ignore the cultural and economic conditions behind his own success. But he behaved as though Bilbao's results could be endlessly duplicated. Conditions were good in America despite the competition from other museums; they were mixed in the Basque Country. They might become explosive in another country where the ideological position of museums was not something you could evade, where audiences might be hostile, where the government would not be so cooperative,

and where the architecture would be asked to carry a greater load of persuasion than it could realistically handle. That was pretty much the plan: plonk down a Gehry building in the middle of nowhere and watch the happy peasants flock to pay admission. And if they don't it's because they Hate Our Freedom.

III

By now most museums are like that; the whole of high culture's like that. The symphony, ballet and the whole apparatus rest on a flawed model of what an audience is and why it comes. Consciously or not, cultural institutions keep circling back to their original calling, which is not to attract the rabble or to keep them out, but to keep them in their place. Lincoln Center is a good example, a cultural complex built in Manhattan in the late 'sixties, an attempted monopoly planned on the destruction and attempted destruction of competing cultural institutions like the Old Met and Carnegie Hall. Placed on a platform like a Moghul's palace, it's of the West Side but above it. It includes two theaters, a library, a concert hall and two opera houses, the Metropolitan Museum of Opera for the elite and City Opera to accommodate the riffraff obscurely yearning for tickets to *Adriana Lecouvreur*. And for years if you turned up with unkempt hair or jeans you took your own life in your hands: watching the guards shoo off the locals was part of the entertainment package served up to the plaid-clad music-lovers from Prosaic, NJ. What Brecht wrote of the Nazis then applies to the cultural apparatus of the twenty-first century: they want to turn the People into an audience. Same policy, different means.

Yet intellectuals manage to believe there are no classes, only social mobility. Conflict only happens when someone or other decides to make trouble, as when a Republican governor accuses a Democratic

senator of "stirring up class conflict" by raising taxes
on the rich. That conflict might come spontaneously
from the lower classes seems empirically ludicrous to
those who choose the empirical data; and the opposite
is so obvious it isn't worth discussing: that conflict
comes from the top down; that it's as unremitting as
the resistance it provokes from below; and that
cultural institutions and practices (especially museums)
have been for centuries sites for the joining or sooth-
ing of conflict between the rich and the poor.

 To argue this last is to argue from either
extreme of the political spectrum. On the left
Bourdieu has shown how high culture speaks in differ-
ent voices to different audiences at the same time,
reproducing and internalizing the image of what soci-
ety is meant to be. On the right the Disgruntled
Directors (and various culture critics at *The New York
Times*) happily assign the same role to museums and
architecture: "Democracy" is okay to the extent that it
divides people into spectators and participants. T.
Krens got stuck somewhere in-between, like a rat
between the dinosaurs and the hominids. "People say
that the distinctions between fields are shrinking," he
insisted. That shrinking was not apparent in the day-
to-day operations of the Guggenheim, or of any other
museum. For starters, the Education Department
faced the agonizing task of figuring out itineraries for
children's tours that would avoid the sight of vaginas
or outsize penises, or men pissing into other men's
mouths. More subtly, there were class-based decisions
every hour of the working day: so the snooty
Frenchman objects when you mention Pissarro's

Caribbean birth? Tough noogies. So you have to tell a group of bored stock brokers why Picasso's important? You tell them about the corporation formed to corner the Picasso market at the turn of the century.

Just because everybody's facing the same sculpture or Harley doesn't mean they see the same thing from the same angle. At the museum social groups and individuals come united by an interest in culture, but they're also involved in a silent struggle among groups and within each individual to define what culture is. If you live off a general interest in culture—welcome to the club. If you ignore the struggle to define culture then sorry, you're missing the whole point of museum-going, and of all education.

It's an old sociologist's sleight-of-hand: define various groups as non-conflictual, then notice with satisfaction that they don't have conflicts. Invent representative fields according to the games played by children ("Soccer Mom") or the sports attended by parents ("Nascar Dad") or, for that matter, their expertise at cross-dressing while driving a Chinese brush with 400 cc's of power. Once you try to attend to those groups, though, you have to decide if you're going to work along the fault-lines or try to patch them up. Every teacher, lecturer or gallery guide knows that the lines are there, that you cross them at your peril, and you can't please everyone. Every teacher knows that his boss doesn't know that, because the boss thinks in terms of double negatives: if you don't offend anyone the pleasing will take care of itself. "Pure Reverie" is a marketing strategy. In the last instance, if not the first.

Wish I was a troubadour, a-sittin' on his ass,
Playin' to the fantasies of the upper middle class.

That won't work: people don't see the same artworks from the same social position. That has been true of museum-going from the start—hell, it was the whole point. Tom Crow, in his masterful book on eighteenth-century Salon-going, tied himself into challah trying to prove there was a "commonality," a single public "with a shape and a will." He was wrong, and now that he's the hotshot director of the Getty Research Institute he's still wrong. Museums and galleries were not and never will be catalysts of a public, oppositional or loyal. There is no Schillerian moment of attraction to Freedom, no Hegelian moment, either, that moment when the very act of signifying becomes, in a flash of divine light, the act of art and the act of worship at once. There is only the ongoing stress of coalescing and fragmenting crowds. Crow saw the evidence as it was, except upside-down. He thought the whole point of the French Revolution, the culmination of his narrative was (once more, with feeling): "the pure reverie that an unencumbered aesthetic experience can inspire." Go tell a Marat.

IV

"Marx may have had it exactly backward. He argued that classes are defined by their means of production. But it could be true that...classes define themselves by their means of consumption," wrote David Brooks, the avowed columnist. Not *exactly*: Marx argued that classes define themselves and others in their active relationship to means of production, including that relationship called "consumption." (And that makes David Brooks a Marxist? *Come on*.) At the beginning of this century fashion is the visible form of consumption, the visible instrument of the fragmentation and reconstitution of class. Just as art history incessantly mines a chasm of its own making between the physical production of objects and their reincarnation as art in the consumer's eye so, too, the museum is an instrument to constitute and fragment museum audiences, and this back-and-front movement occurs simultaneously, incessantly. As Guy Debord put it, "the unification accomplished is nothing but an official language of generalized fragmentation." And vice-versa, of course.

In the Baroque Era high culture set up mysterious barricades between the watcher and the watched—that was the point Habermas made, and failed to pursue. For the time being power belongs, as before the French Revolution, to the watched; and the calling to be watched is a definition of class. This scenario has been anticipated at Lincoln Center whose architecture, wherever you look, is designed to rub in the lesson: Behold your Betters. The concert hall's

seating is arranged so that the cheaper seats don't face
the orchestra, they look down on the gentlefolk below
as in certain Baroque churches and palaces. Each land-
ing is cantilevered above the others so at intermission
you can stand and admire the fuhs below. Both the
concert hall and the opera have upscale restaurants so
placed that you can't avoid seeing them. At the
Metropolitan Opera you spend intermissions gazing
down at the folk enjoying their dinner: *Oberon*'s on
hold until they've polished off their strawberries. In
the visual arts the same pattern goes back to the
'sixties as well, when the US Government sent artists
abroad to act out in front of foreign audiences. It was
present, also, in the conceptual art of the 'sixties and
'seventies, the kind of artworks the Guggenheim
collects, works that document an event that happens
to have taken place somewhere else. To be placed in
front of a fuzzy photograph about something Ana
Mendieta or Robert Smithson once did in the depths
of Yucatan is to be placed in front of a performance
only Mendieta and Smithson and their *very closest*
friends have been privileged to witness.

By now the process has become so common
there's no need to go to a museum to enjoy it
anymore, or rather to be enjoyed. Fashion consists in
having something others can envy. Elaborate scenarios
and gimmicks are enacted, for proper payment, to put
the customer on stage: cell-phones, Karaoke bars,
disco bouncers, political conventions, first-class seats
on airplanes. Screwing and pissing in public are in
style. Democracy is a spectator sport and the task of
the museum is to offer the opportunity of being

among the watched. Audiences, too, have been separated into subjects and objects. Democracy is a performance for the benefit of the actors.

More and more the audience is dragged in to see the elite, not the art; often they're dragged in to see nothing at all—a series of orange stanchions in Central Park, for instance. More and more, the audience wonders why. Why pay good money to be frisked, or humiliated, or shooed away, or bored? When Krens insists that "the function of a museum is to create a situation in which viewers do not feel they are tyrannized" one has to wonder if he means tyrannized by the content of the museum, or its staff. If it was tyranny to bring in those black kids to listen to a lecture on Mister Morgan Sir, was it less of a tyranny to bring in motorcycle enthusiasts to look at motorcycles then exclude them from the construction of the narrative of motorcycles? Krens claimed democracy consisted in not forcing people to plunk down fifteen bucks to see something they never wanted to see anyhow, but now, after 9/11, that's not his problem any more. His problem now is bringing them in.

A dog with a bone in his mouth doesn't bark. This has been the guiding principle of American cultural policy since the Nixon era: as one official report explained back in the 'seventies, it's harder to burn down the ghetto when you've got a saxophone in one hand. Forty years later the bone is long gone, and the saxophone, too, but the American public is still expected to sit there panting and wagging its tail.

But for how long? Here Krens is at a disadvantage: Pure Reverie doesn't come from the Pure

Reverie Fairy, it's nurtured from kindergarten on—or rather, was nurtured, until the funds were cut, at which point aesthetic education became, as it had been earlier, a defining privilege of the upper class. But while being fashionable is nurtured, too, it will probably never be nurtured enough to smooth over the logistics of bringing in motorcycle enthusiasts one week, Aztec freaks the next. There's a fortune spent in Europe and America persuading people that High Culture is good for them and there's a great deal spent persuading people to be fashionable, but it's a lot harder to persuade people to look at such-and-such a painting or ride a bike or grind stick ink if they don't want to. This was shockingly obvious when the money ran out after 9/11 and the Guggenheim cut down on advertising. As advertising went the reviewers ran for cover, and admissions crashed. Krens by himself didn't have the capital to buy up the Kimmelmen of this world. Whether that capital was symbolic or hard, cold cash, I don't know; ask *The New York Times*. The Guggenheim Museum, like the American culture industry, like the American economy as a whole, is living beyond its means.

Compared to the Tyranny of Artistic Reverie the Tyranny of Fashion is a joke. Both are at bottom manipulative and both by now are less and less effective. Academics and art-critics love to bemoan the coerciveness of culture, but museum audiences have not read Debord and Foucault, and if they have it's probably in a more critical spirit than the "resistance is futile" crowd in the academies. No doubt a number of visitors come to the museum to see, to be seen, or to

be seen seeing. Quite a few come—the majority, actually—because they know motorcycles, or fancy clothes, or Chinese calligraphy, or because they see in each of those something that connects to their lives in a real way. From the outset Krens just wanted them to keep on coming; he wanted the twin balance sheets "fashionable" and "finance" to match up. He wasn't particularly interested in controlling what they saw, or even how they saw it, and the same archaic relations of production have now returned to bite him, bite us all, in the butt. In the traditional art museum today the people are allowed to be spectators; in the Guggenheim Museum they may on occasion be spectators of who they are; in no case, either in art, or politics, or museum-going, are they ever allowed to be participants.

FOUR

Rio: the highest stage of Bilbao

When the Portuguese landed in Brazil they were encountered by a number of tribes that practiced ritual cannibalism. A group of warriors, coming face-to-face with the Europeans, would proceed to explain in great detail how they planned to eat them, with which torments. This gave the Portuguese plenty of time to light up their muskets and smoke them. One tribe however, the Aimoré (meaning, roughly, "the Unwashed") had no such rituals. The Aimoré didn't care for fashion, they simply liked the taste of human flesh, so they'd creep up on an unsuspecting Portuguese, bop him, and drag him home for dinner. It took the settlers a century to get over the Aimoré. When Krens landed in Brazil he met the same fate— metaphorically, of course, as I am sure you will be relieved, gentle reader, to hear.

The idea was to do to Rio de Janeiro what had been done for Bilbao, Spain. But Rio is no Bilbao. The Guggenheim's partnership of International Modernism and upper-class Euroculture is nothing new to Brazilians, many of whom are descendants of slaves, some of whom are descended from Indians, all of whom are sensitive to the interactions of class and ethnicity, *obligado* have a nice life. Brazilian Modernism is a rich-white-immigrant thing that doesn't merit the accolade of: sucks. Besides, Rio already has its own Museum of Contemporary Art built by its own Frank

Lloyd Wright, Oscar Niemayer. Been there, been done by that. There were demonstrations, legal actions, and suddenly the project was called off, leaving a minor problem of a million dollars spent in design fees. The only problem now is the one that confronted the original Portuguese settlers: getting stuck for drinks. The majority of Krens' overseas projects have ended up like that, the museum equivalent of the nineteenth-century Englishman in his armchair, swatting away mosquitoes, waiting for the weekly packet and reading year-old copies of *Artforum* while restless shadows flit through the global jungle.

The advent of Guggenheim Rio was to be celebrated in New York by another blockbuster, starting with a Baroque altar some thirty feet high and leading up, up, up to the stars. The show had been designed by the French hipster and one-time architect Jean Nouvel. The whole rotunda was painted black, bathed in darkness, so that the visitor stumbled upwards, past the art of primitive savages and slaves, upwards, ever upwards, until he, she or it emerged into the sunlight of white-folk art and white-folk architecture, so close to Heaven. There was no doubt as to which segment of Brazilian society was behind this.

For the first time I was ashamed to work at the Guggenheim. One day I was standing halfway up the ramp, in front of a fine wooden Christ by Aleijadinho, the great mestizo sculptor and architect of the late Baroque. A colleague came along, with a tour group behind her. She stopped. "This is Al...uh...this is...Hey, notice the contrasts of red and brown?"

Hey, kids: can you say "Aleijadinho?" Nine long years I'd survived because nobody upstairs cared what I said or thought, and now the chickens were coming home. Nine years I'd kept my pride because, no matter what anybody said or thought upstairs, I was doing my job, and doing it well. That was when the future was inevitable, and the future was with Krens. But this was our art, and this was our museum, and an artist's gotta do what an artist's gotta do. When I started working there I'd got into the habit of turning up early to give a tour, hanging inside the lobby in my suit and tie, watching things unfold. After a while I started to look like someone in charge, and people started coming to me with their problems, and when I began to notice how intimidated people were by museums I started working with that. And if people were intimidated by admission prices, well—we had our ways.

My new assignment (from me to me, with love) was to demystify the art and the experience, and if that meant a critique of the museum itself, of its shady doings, its myths, its manipulations, and if I could do that and make you smile and think, and bring us all a step closer to World Revolution, then *a sus ordines, Señor*, and nobody upstairs seemed to mind because nobody was listening from upstairs—I never once saw Krens on the museum floor during opening hours. And the visitors loved it and came back for more because they got something worth their money, even if it wasn't ideologically fruitful for the institution: art criticism, criticism "partial, passionate, political." Especially if it wasn't ideologically fruitful for the

institution. But bringing in visitors is the bottom line if you're a free-market capitalist like me, right?

Every successful business is run by a workers' council, except that under capitalism the council operates behind the back of management, or in spite of management or at best, as in most museums and colleges, with the inexpert tolerance of management. And since self-criticism is crucial to the running of a business the business of all workers is a critique of the business itself, a demystification of what the business is about. My task as a lecturer was to question the authority of the museum, of all museums, and my own authority within them. One day my colleague Rosemary and I met in front of Rauschenberg's *Bed*, each with our groups in tow. So we played dueling lecturers, throwing arguments back and forth, contradicting, fielding questions, demystifying our own roles. My friend Filip Noterdaeme opened an alternative museum, a kind of shadow Guggenheim, the Homeless Museum, and it was like opening the doors to a gust of iced air. All of us (Fil, Rosemary, Elizabeth, Hannah, the late Pearl Ehrlich, all the others I can't begin to thank), we were building the kind of audience—urbane, knowledgeable, independent—that you still find at Carnegie Hall but nowhere else in America. That's why Carnegie Hall is still successful and Lincoln Center's a dreary, Tchaikovsky-belching bust. That's why people go to museums.

For all of us, the guards and staff and lecturers who took their jobs seriously, content mattered all along: the content of the art and the content of the museum, and the wider social implications in varying

degrees. By the time I left content mattered in the back office, also: it was important that there be none, just reverie. By then there was no interest in art, or art criticism, or even in teaching the staff how to pronounce "Aleijadinho."

In all fairness my supervisor (known here and there as Shmegeggy Guggenheim) worked hard at this. Shmegeggy was one of a new breed, the deadliest legacy of the Krens years: a museum professional with an advanced degree in anything but the actual content of museums. This ensures that those selected to work in museums are so lacking in basic human skills that they've had to pay thousands of dollars in tuition just to acquire a poor, plodding sense of those skills. For Shmegeggy it was all fashion (also known as art appreciation), and fashion consisted in watching yourself looking at art. That's when most men disappeared from the Education Department, a good indication of how meaningless and demeaning our activities were meant to be. As in most museums education was on a par with nursing, child-rearing and social work: girlie stuff.

The kids were the first victims. In America you get busted for physically touching a child but you get grants to twist their brains into pretzels and there will always be plenty of foundations willing to pay you to do it and plenty of museums to take the cash. Nobody cares what the kids think anyhow, though if you want to know: the kids *hate* it.

It's hard work teaching others to be ignorant, which is what teachers are paid to do in America. It's even harder to play stupid when you're smart, or igno-

rant when you're knowledgeable: look how many of us are dismal failures at it. Most kids know that, and grownups occasionally remember, too. Disinterested interestedness is not that interesting to many Americans, and the new Guggenheim was more of the same. Unlike grownups, kids have no say in whether they go to the museum or not. Unlike kids, grownups do.

Museums are in crisis, and they won't face up to the real reasons. Way back in the 'sixties William Schuman, president of Juilliard, coolly reminded the Rockefellers that Lincoln Center was not simply a bottomless money-pit, that was its actual purpose. It wasn't about art or the money, it was about creating an insatiable field for speculation in real-estate, in services, in ideological control and manipulation. Now the monster's out of the box: as the actual use-value of the art declines (meaning its ability to draw visitors) its investment value increases because it takes more and more cash to continue to valorise the art and that calls for more speculation, which in turn brings in more speculators: the dog notices it has a tail, and wags it. The Museum of Modern Art just recently splurged on a new monster building, and it's the first building I've ever seen designed to look like a cheap temporary structure from the get-go: it reminds me of that myth-ical midwestern college whose dorms were designed to look like grain silos since that was what they were going to be once the founder's son graduated. A private group of well-heeled investors has taken over the not-for-profit foundation behind the planning for a new cultural complex at the former World Trade

Center and has begun, very sensibly, to exclude the cultural component as too costly. All art tends to the condition of real estate.

Krens, too, got caught up in the spiraling cost of getting people interested in something they just aren't that interested in. As of this writing he continues to believe another roll of the same loaded dice will save him from his Nietzschean Will to Deficit. When Peter Lewis, the Guggenheim's chairman, grew concerned, Krens fired him for gross fiscal competence with the help of a Board packed with real-estate speculators. *The New York Times* calls this a victory over money, which it is: a triumph of the belief that art makes money over the certainty that money makes art.

And as the use-value of artworks declines the coerciveness of the means used to enforce their exchange-value increases. MoMA hiked its admissions fees into the stratosphere but its audience, though shocked, has not been awed. In Rome the Galleria Borghese set up a Byzantine system of required advance reservations and an assembly-line schedule for visitors. As earlier in the post-Tridentine Era, so, too in the Pre-Post-Chewing-Gum: our rulers have switched from selling Heaven to selling its inaccessibility. Some object this is cultural suicide in Rome, a city of casual, constant, and free enjoyment of art and architecture, but culo-heads prevail. One day at the Guggenheim Shmegeggy came up to tell me I was no longer a "Lecturer," but an "Educator." I stuck on my shades, crossed my arms, and in a dark monotone I said: *I ahm de Edukatorh*. That must have inspired Shemegeggy because soon afterwards a new job slot

opened, Educator and Security Guard in one. When I hear the word "revolver" I reach for some culture.

Tyranny, it turns out, isn't such a bad thing after all. The same thinking presides in Iraq where, we are told, the world's terrorists are turning up like flies to poop, driven by an irresistible attraction to Freedom and Democracy which in turn affords us the opportunity to kill and torture them and loot their art. In the museum as elsewhere the dark-side followers of Schiller are back and running the place, and as usual their message is: YOU WILL EAT SHIT, AND LIKE IT. By now the falcon no longer hears the falconer.

Krens believed in the green.

He also believed in the art. Problem is, he believed in them both in the same fashion. He was a commonplace of the 'nineties among artists, curators, and museum directors: most thought of themselves as the next Lenin, sniffing the winds at the Finland Station of Culture. Most actually were dull CEOs floating on a cloud illusion that economics are the scientific mapping of an inevitable upward spiral and they need only know the science to drift upwards with it. At the tail-end of modernism K.'s vision of the museum was something like a DNA strand: two parallel systems, one based on the belief that art would improve us, the other based on the belief that money would; built, actually, on a slipshod model of capital, symbolic capital, and their relation.

Bertolt Brecht, when he took over the Theater am Schiffbauerdamm *in East Berlin, had the gilded cherubs and narrow loges preserved: he wanted to maintain the contradictions between the theater as it claimed to be and the society it confronted and lived on. If culture stood for something then the participants (the viewers, the actors, the artists, the directors) had to decide where they stood and what they would sit for.*

Yet even today we cultural workers, right or left, we cling to our old system of double-entry bookkeeping, art on one side and money on the other. We struggle to change the forms or culture while desperately grasping to maintain its social functions, which turn out in the last instance to be its economic functions as well. It just won't work.

Some day there will be an Art History that is also Art Criticism; that engages works of art directly where they are and as a function of where they are, where they come from, and where they're going; and whose task is to defibrillate the present in the agonizing body of the past.

Till then we butt up against the problem Krens could not confront, of following Schiller into a post-Schillerian world. And so we beat off, armed against the future, ceaselessly bored into the past.

A Note

There are no footnotes. Most of what I've written is common knowledge, much of it is from direct observation, some of it is logical surmise and some of it is supposed to be funny. For those interested in pursuing the ideas raised here there's a working, running commentary and an annotated bibliography on my website, at http://museuminc.net. Complaints and corrections will be posted as warranted.

The epigraph by Howard Nemerov is from the poem "Style," in his collection *The Blue Swallows*, and is reprinted by permission of the author's estate.

Also available from Prickly Paradigm Press: